DEDICATED
TO MY BEAUTIFUL NIECES,
SELENA, VANESSA AND SYMPHONY

NO PORTION OF THIS BOOK MAY BE REPRODUCED MECHANICALLY, ELECTRONICALLY, OR BY ANY OTHER MEANS, INCLUDING PHOTOCOPYING WITHOUT THE PERMISSION OF THE CREATOR OF THIS BOOK.

COPYRIGHT © 2014 JERIMIAH J. KIMMEL

ALL RIGHTS RESERVED.

Ant Farm Crossword

Answer the clues to solve the problem.

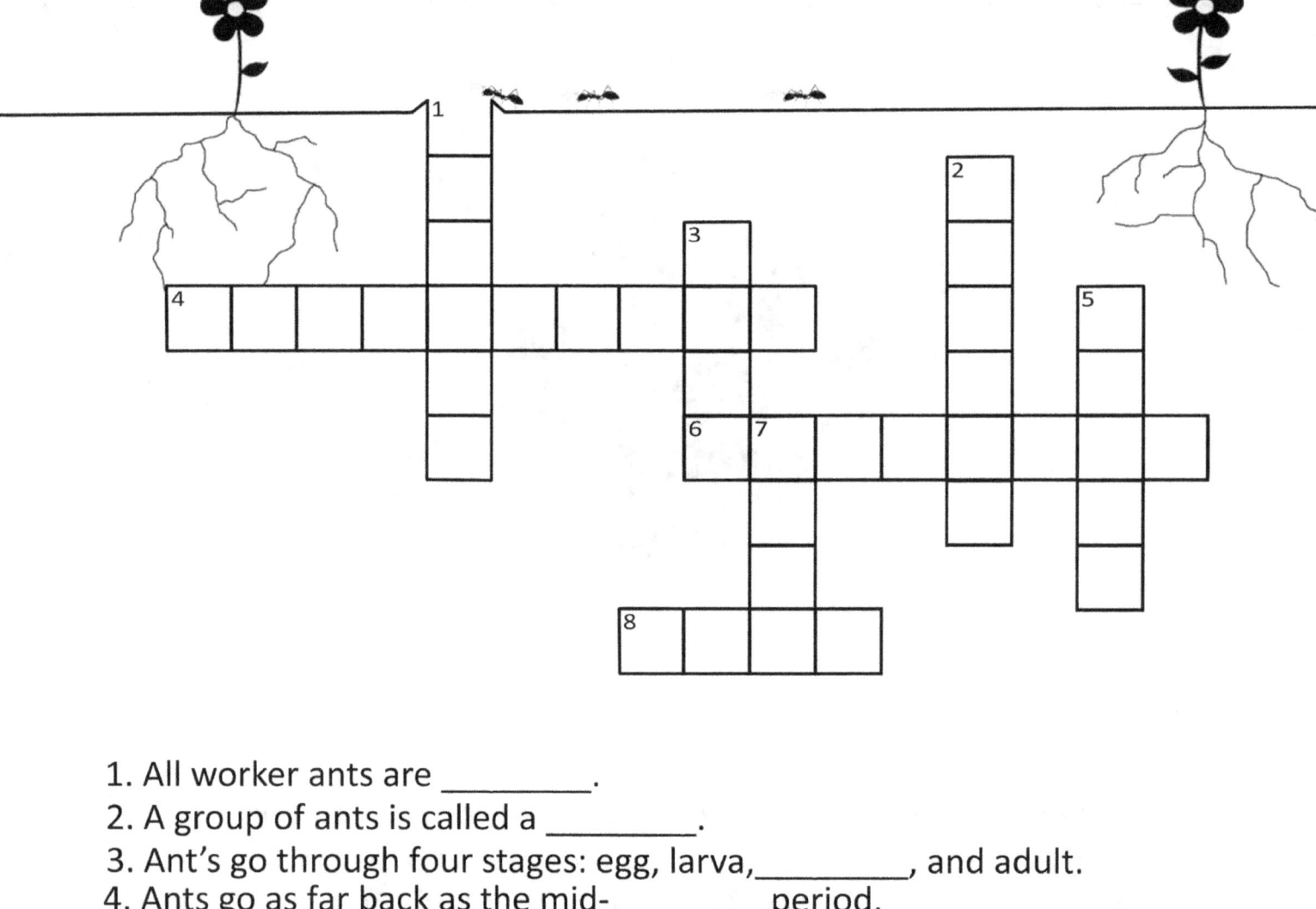

1. All worker ants are _____.
2. A group of ants is called a _____.
3. Ant's go through four stages: egg, larva,_____, and adult.
4. Ants go as far back as the mid-_____ period.
5. Ant's are animals known to have the largest _____ in proportion to the size of their body.
6. The _____ are organs used by the ant to smell, touch, taste, and hear.
7. A ants home is called a _____.
8. In the movie "A Bug's Life" the Princess name was _____.

The total biomass of all ants on earth is about the same as the total biomass of all the people on earth.

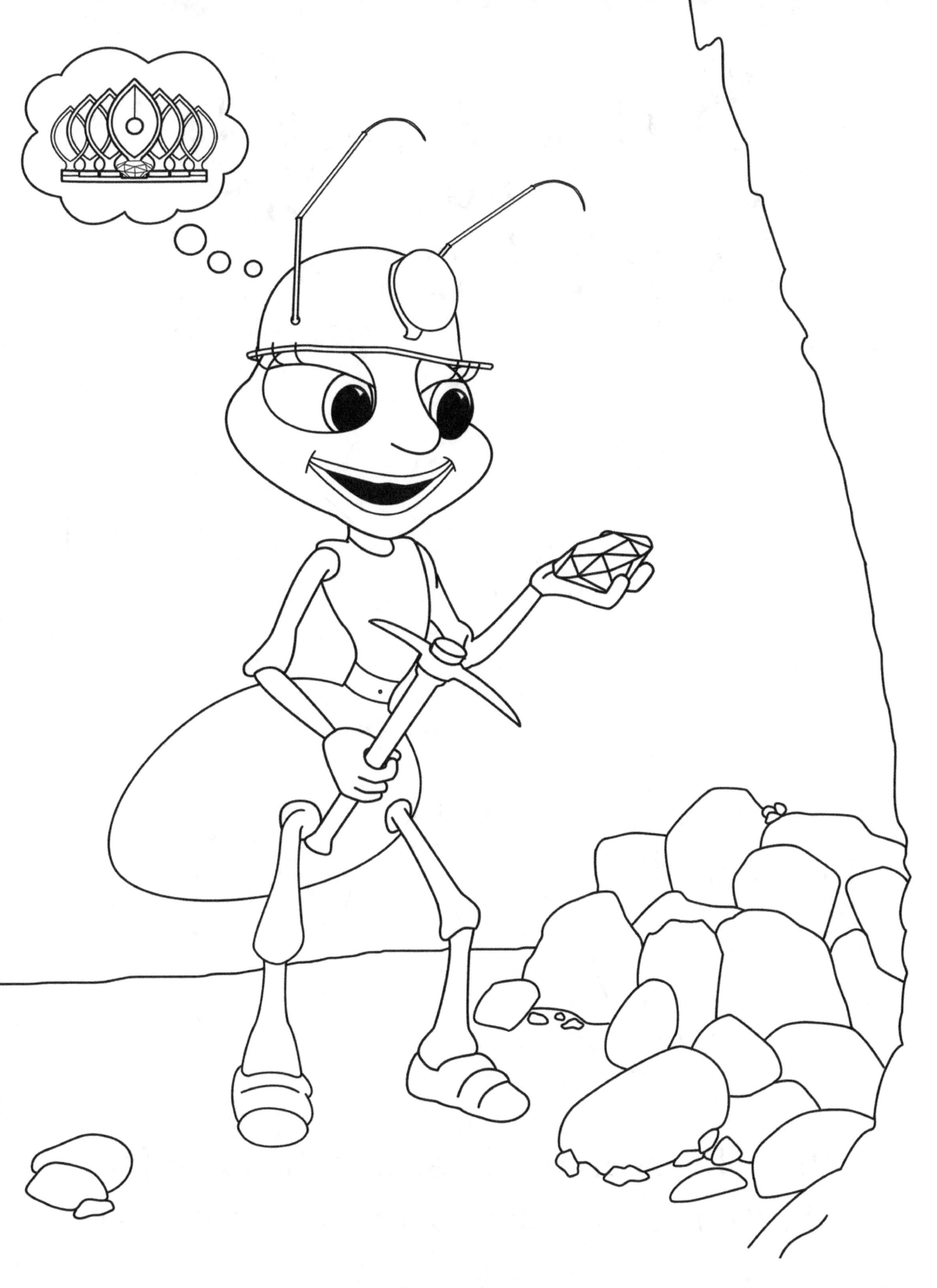

Beautify your Butterfly

Butterflies can not hear but they can feel vibrations, they also taste with their feet.

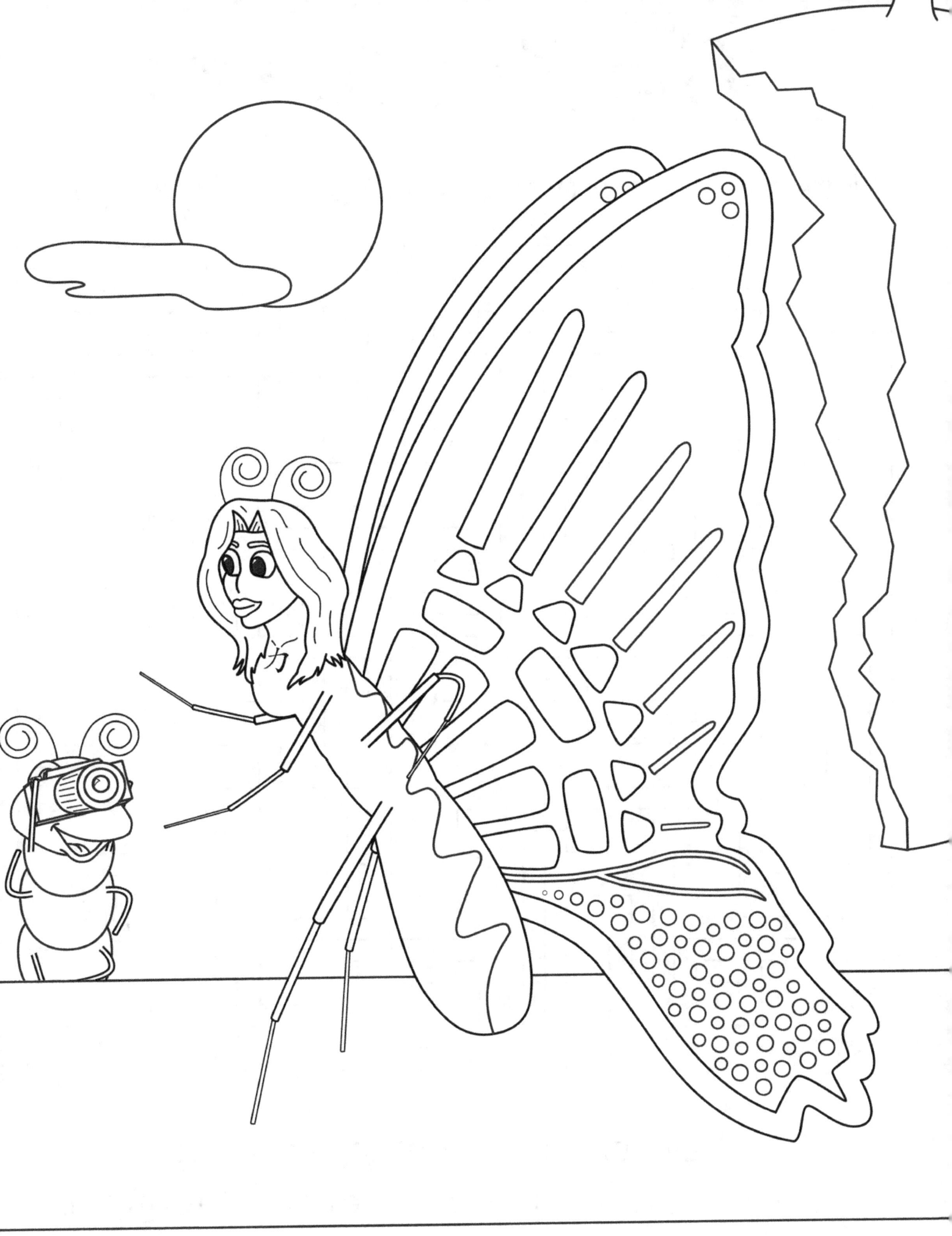

The Rat Maze

Help the rat get to his piece of cheese and don't get caught by the mouse trap!

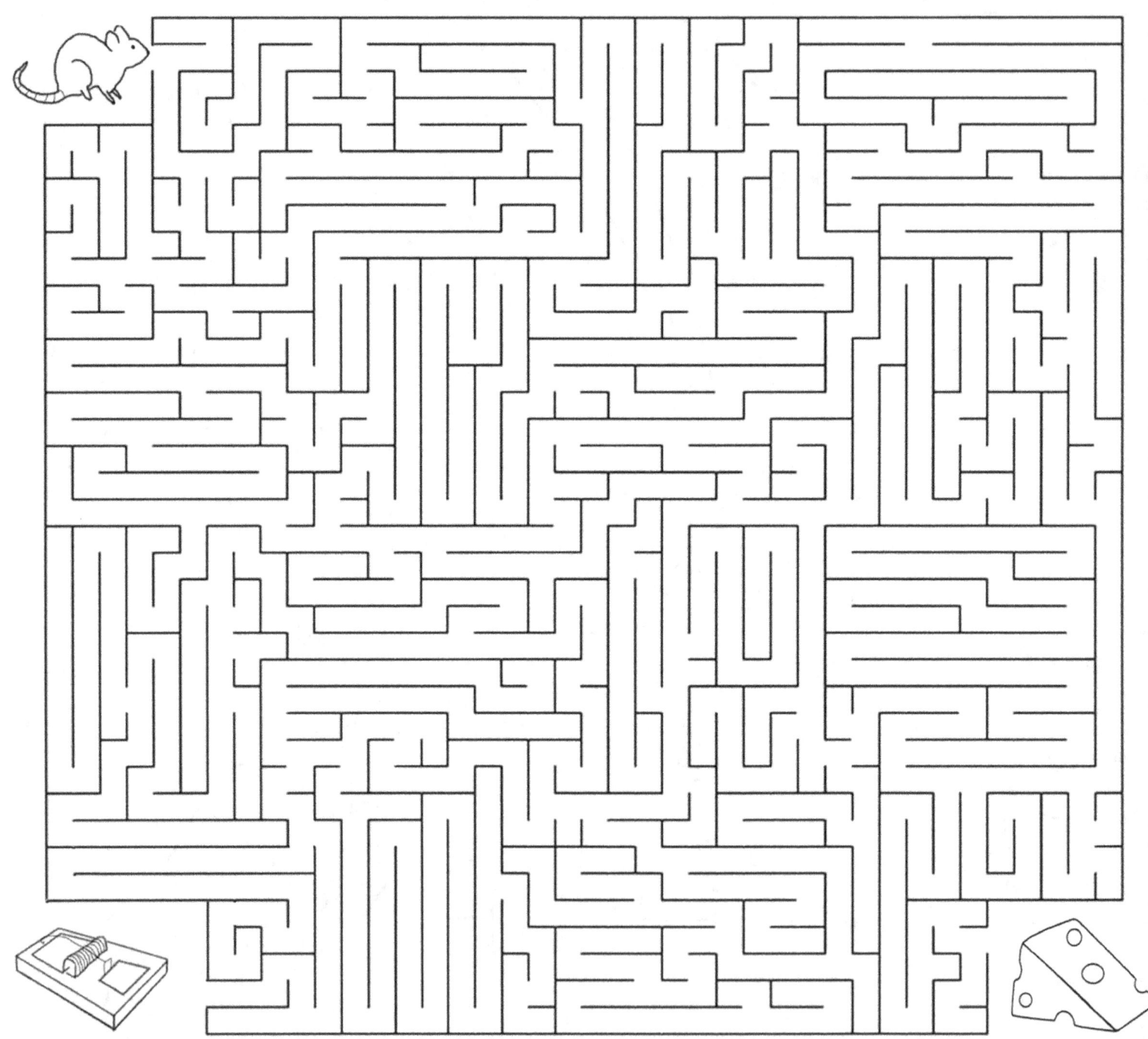

Rats have excellent memories. Once they learn a navigation route they wont forget it.

Famous Bunnys

Fill in the blanks to reveal the answer in the box.

What is a bunnys favorite holiday to celebrate?

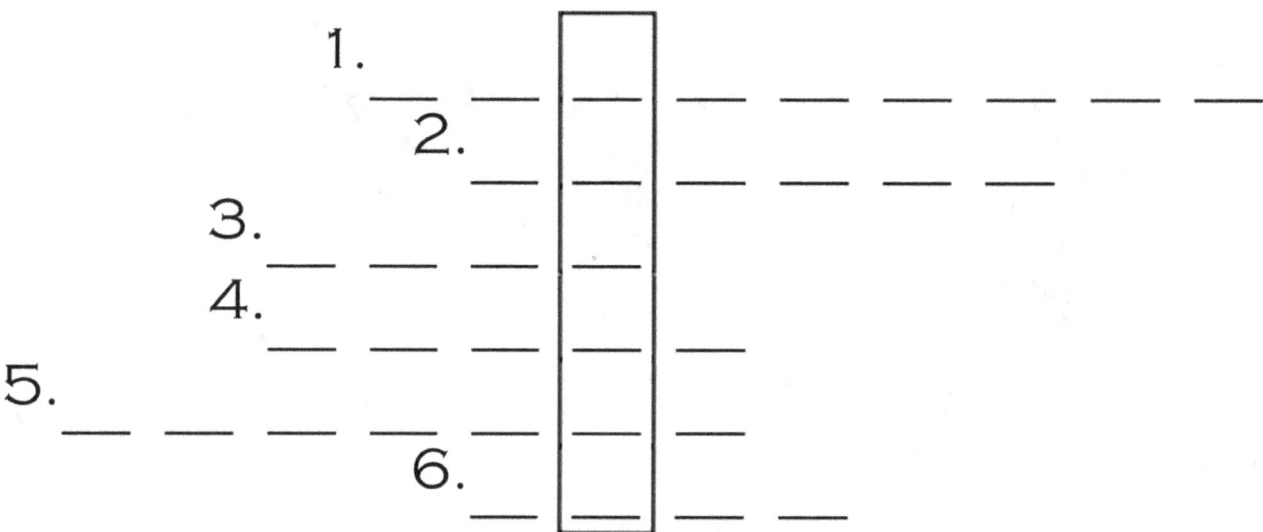

1. This bunny is a mascot for a battery company.
2. This rabbit is Winnie the Pooh's friend.
3. This bunny is the star of Looney Tunes.
4. This rabbit was in Alice's Adventures in Wonderland.
5. This bunny was in the movie Bambi.
6. This rabbit is on a box of cereal.

Rabbits are born blind but grow up with almost a 360° view, allowing them to see behind them.

ICE CUBES MANIA

Rules of game: The game is played by two or more players. Players take turns drawing a line connecting two dots that are next to each other. The player that makes the final line to complete a ice cube wins that ice cube and places their initial inside. After winning a ice cube, the player is given another turn. If a player does not win a ice cube, then it becomes the next player's turn. The game is over when all ice cubes have been completed. The player with the most ice cubes wins!

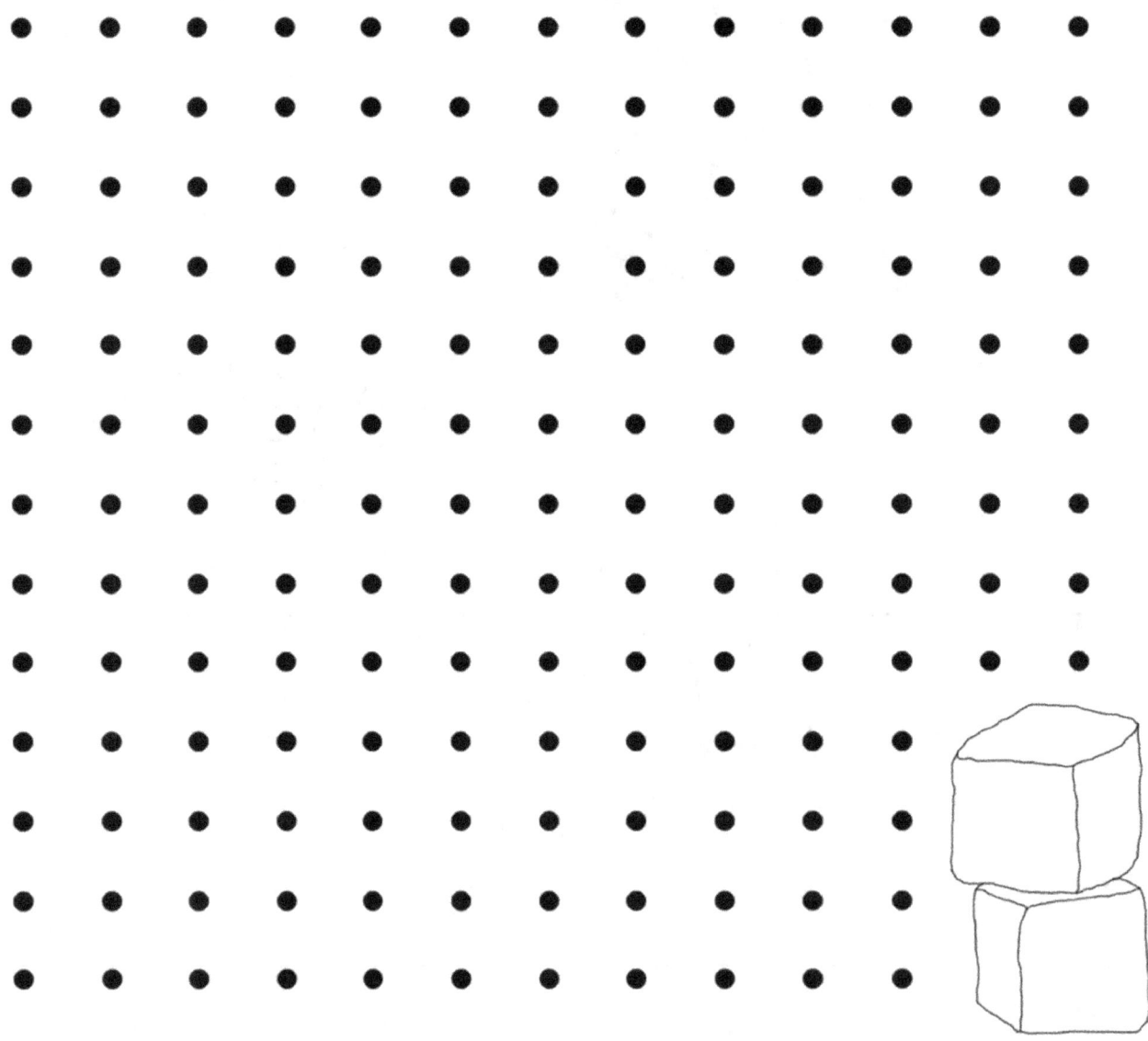

Penguins can drink salt water since they have a special gland that filters salt from the bloodstream.

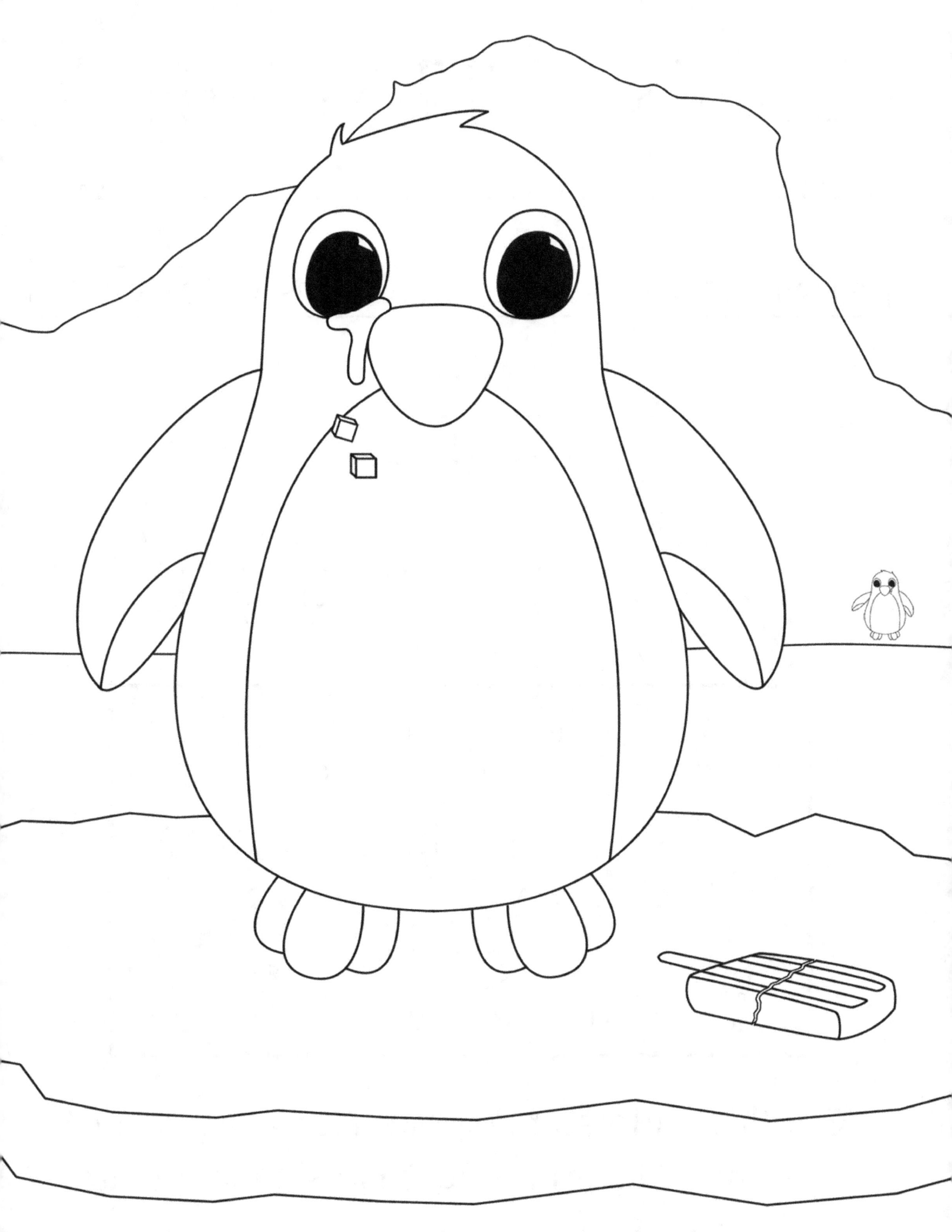

SIGN WITH ME

Write the letter for each sign to spell out the sentence.

| WHAT DID THE GORILLA CALL HIS FIRST WIFE? |

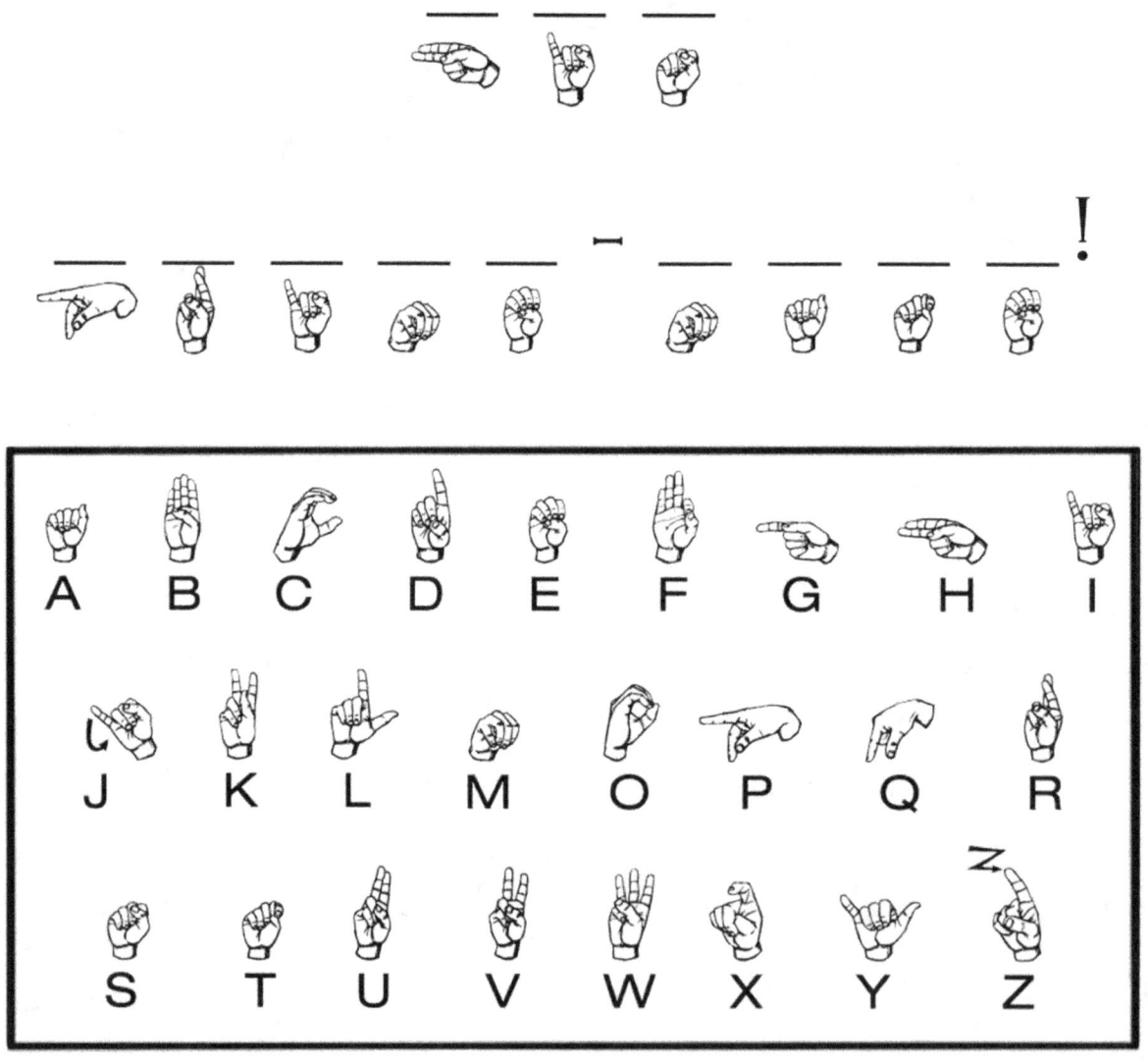

Gorillas understand spoken languages and can learn to communicate in sign language.

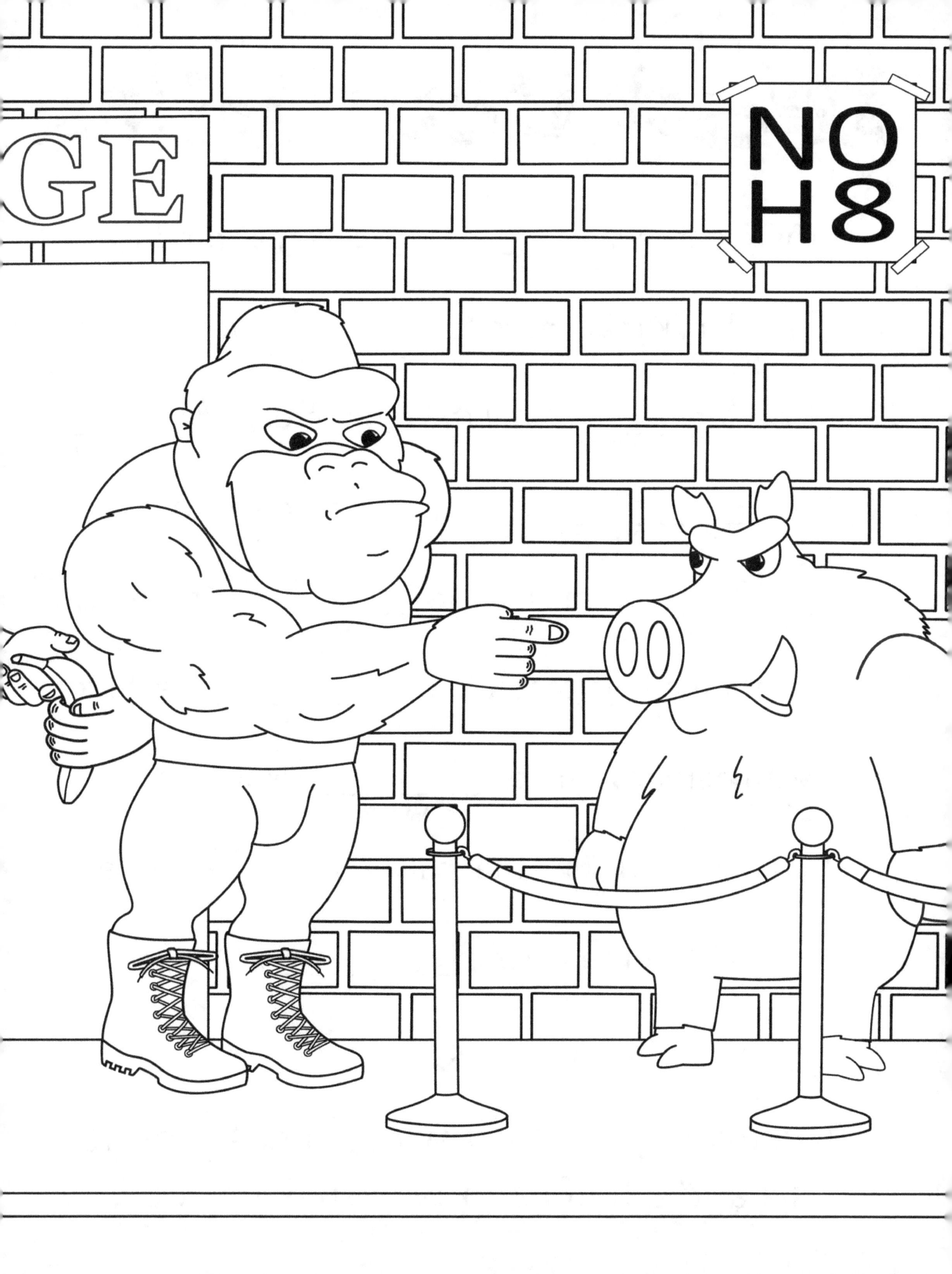

Mad Cow Libs

There once was a _____ cow that produced
 ADJECTIVE

magicial milk that I gave to _____ which made
 PERSONS NAME

this person _____ all the time screaming _____
 ACTION

_____. The milk was the color
 QUOTE

_____ and smelled like _____. They had
 COLOR SCENT

also informed me that it had a _____ taste to
 FOOD

it with perhaps a hit of _____. Now after ___
 SEASONING #

minutes of drinking the milk non stop they have

turned into a _____.
 ANIMAL

The average dairy cow produces around
six and a half gallons of milk per day.

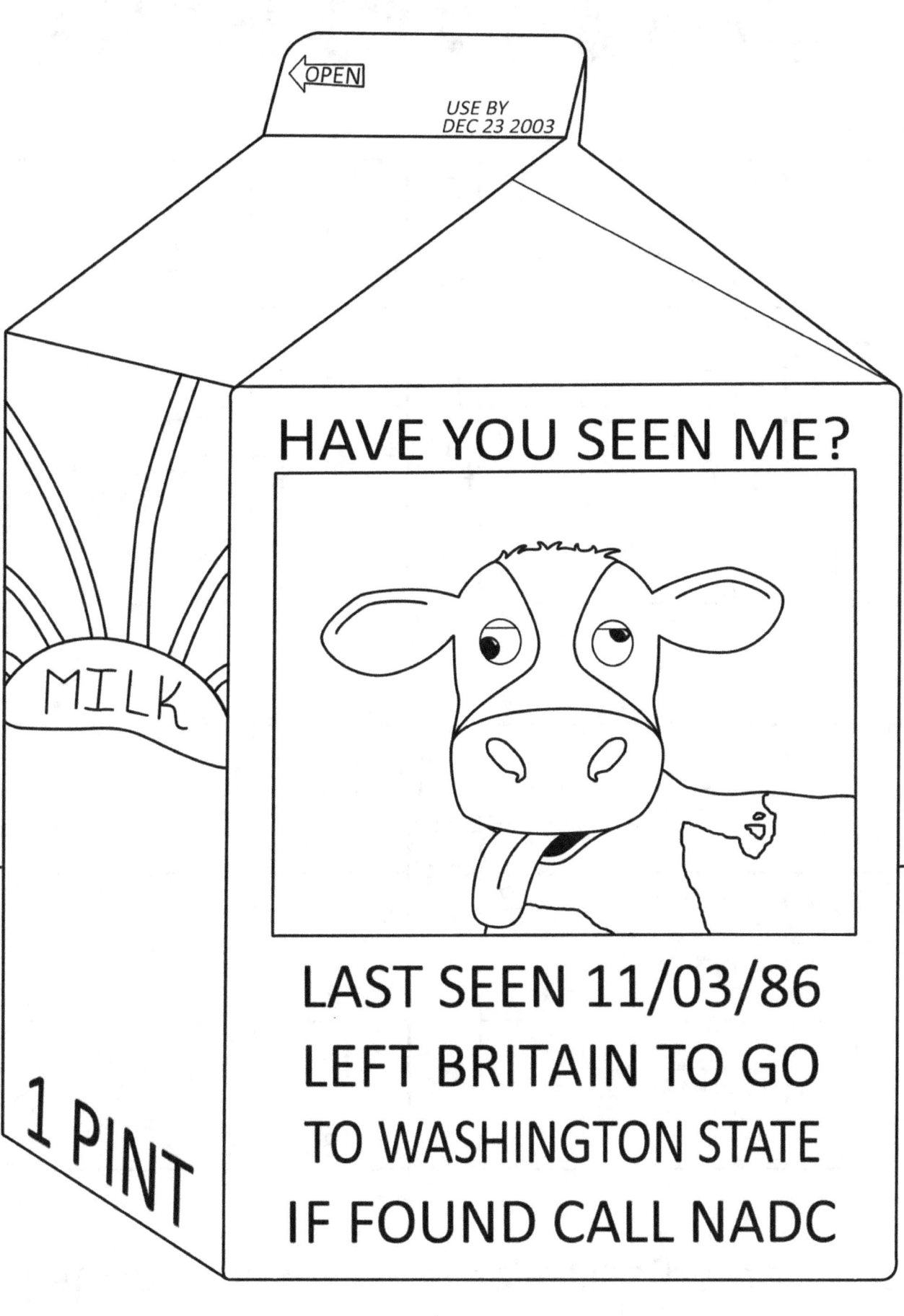

Sudoku

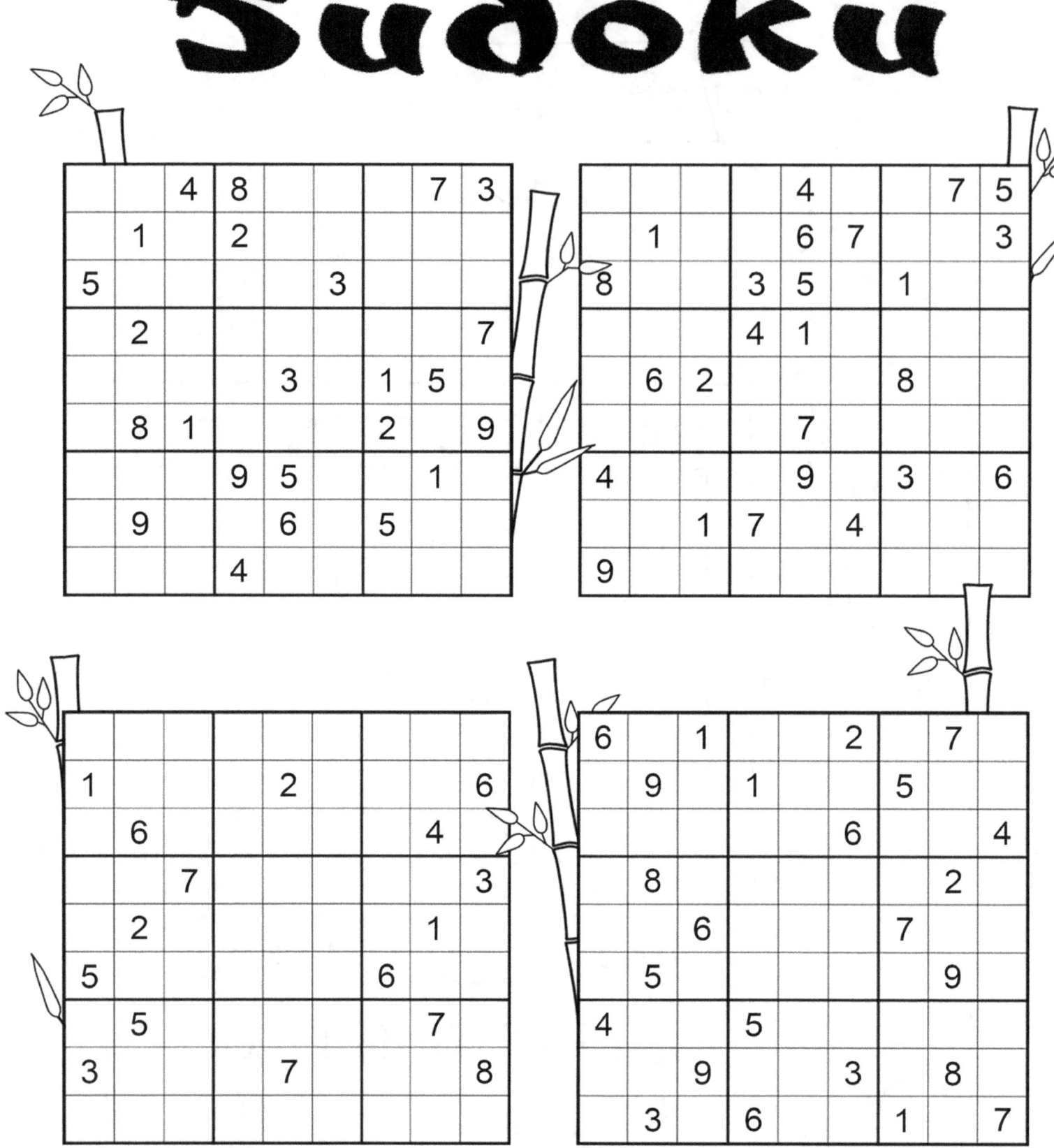

Pandas don't digest plants very well causing them to spend 14 to 16 hours a day eating bamboo.

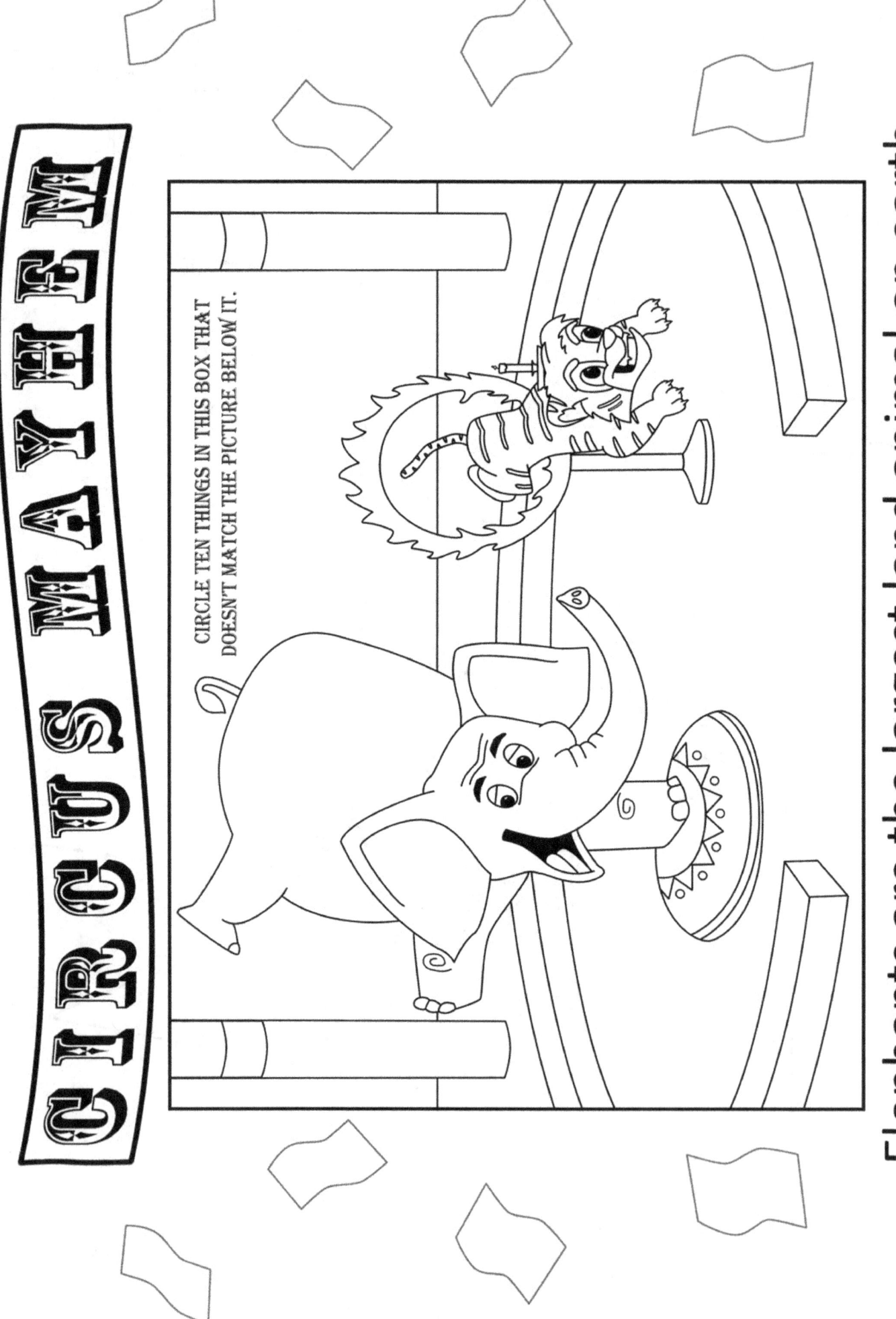

CIRCUS MAYHEM

CIRCLE TEN THINGS IN THIS BOX THAT DOESN'T MATCH THE PICTURE BELOW IT.

Elephants are the largest land animal on earth and the Siberian Tiger is the world's largest wildcat.

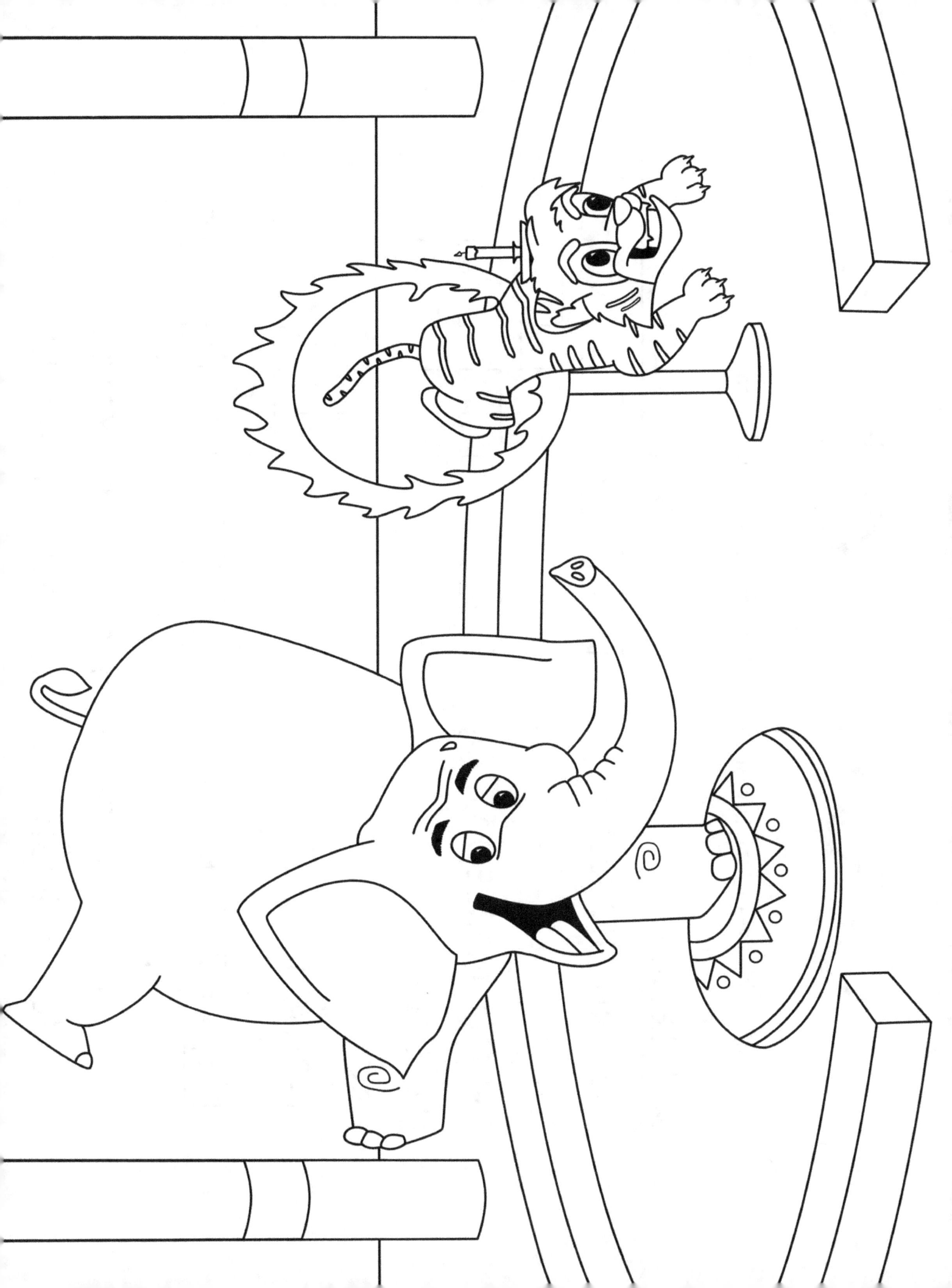

Wild Cats

Unscramble the words below, then use all the letters in the bubbles to solve the phrase.

AHETEHC

AUONMTIN OLIN

GIETR

WSON PDRLEOA

AURJGA

RAGOUC

HTPNARE

☐ ☐ K ☐ W ☐ ☐ T ☐ ☐ C ☐ ☐ ☐ ☐ ☐ ☐ D ☐ D.

Cats can see at light levels six times lower than what a human is capable of.

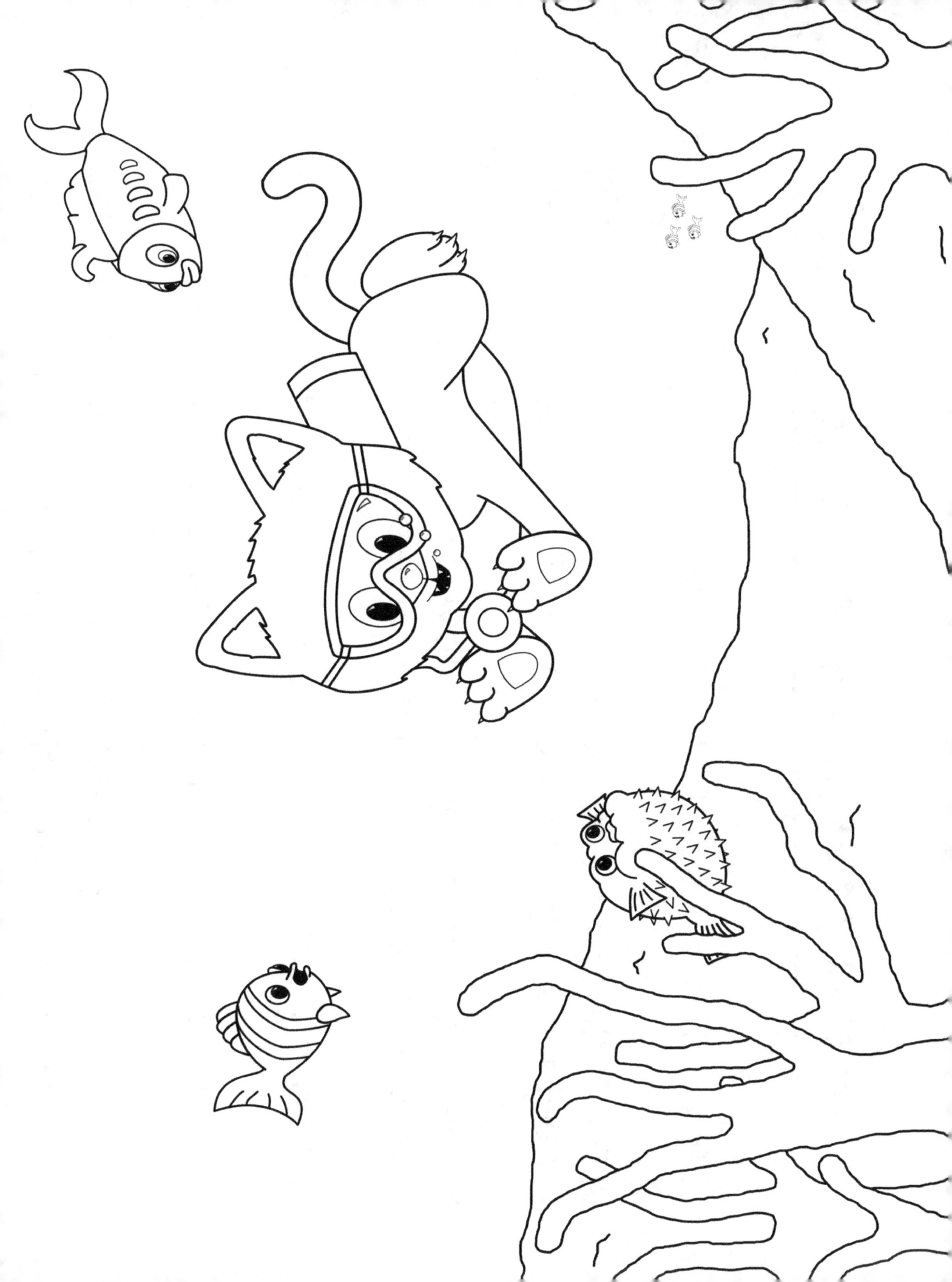

Animalia TRIVIA

Circle the correct answers.

1. The octopus has (1, 2, 3, 4) hearts.

2. The fastest animal in the world is the (cheetah, peregrine falcon, sword fish, turtle).

3. The worlds largest eggs are layed by a (whale shark, ostrich, anaconda, elephant).

4. A young male horse is called a (mare, colt, filly, stallion).

5. A rhinoceros horn is made of (bone, keratin, cartilage, scales).

Giraffes tongues are tough and covered in bristly hair to help them with eating the thorny Acacia trees.

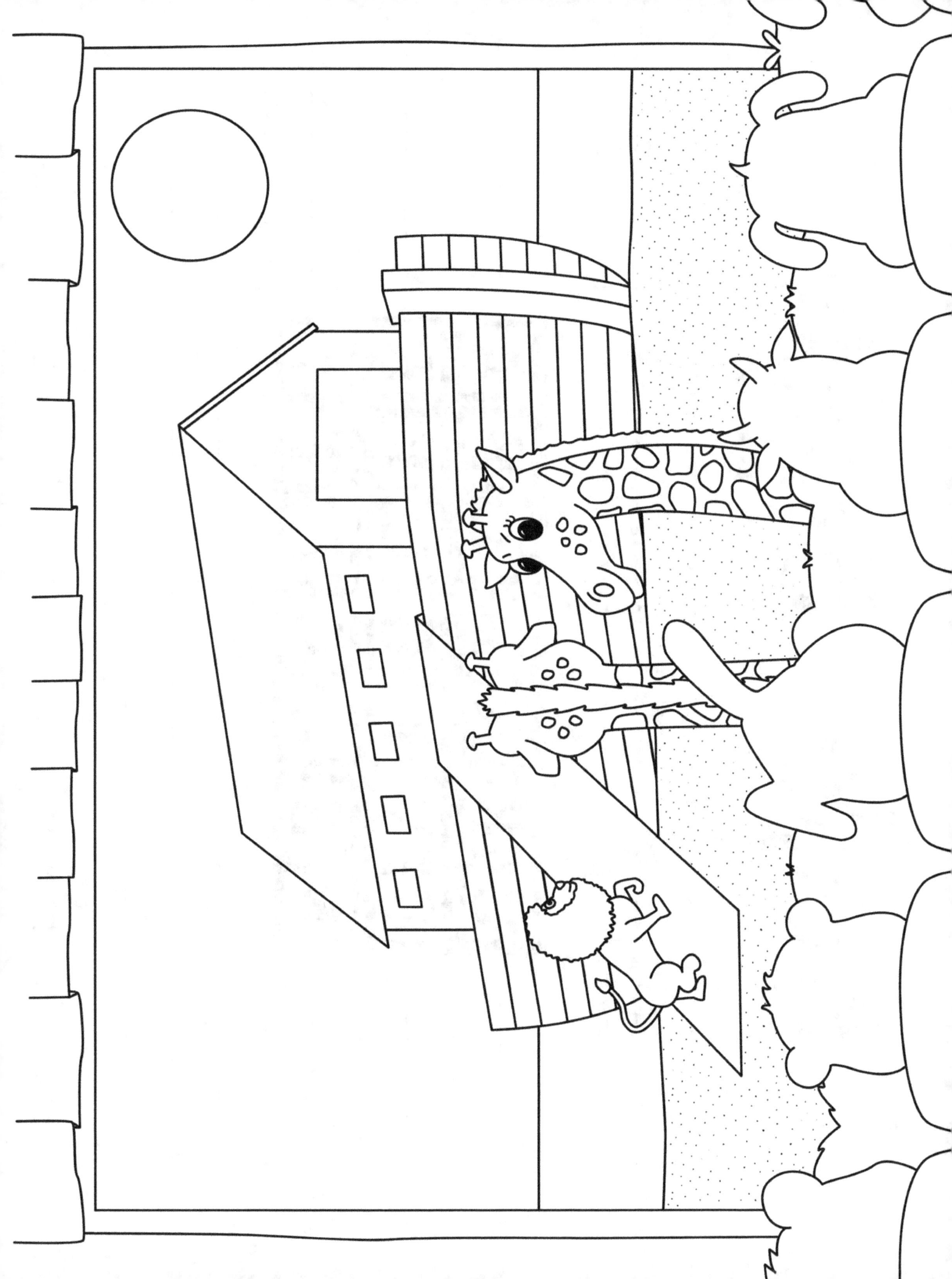

Bogle Boggle

Write down as many words as you can construct from the letters of sequentially adjacent boxes, where "adjacent boxes are those horizontally, vertically, and diagonally neighboring. Words must be at least 3 letters long. You may not use the same letter box more than once per word.

C	R	A	D	T	B	A
O	Y	K	O	L	E	R
N	S	C	G	L	T	I

A Bogle is a mix breed between a Boxer and a Beagle.

DINO MATCH

Draw a line from the description to the Dinosaur it belongs to and then put a box around the Dinosaurs that were carnivores.

Heavily-armored body and massive bony tail club — Tyrannosaurus

Large and elaborate cranial crest — Ankylosaurus

Long neck, small skull, and large overall size — Triceratops

Massive skull balanced by a long, heavy tail — Dilophosaurus

Large bony frill and three horns — Pterodactyl

Has a wingspan up to 40 feet wide — Brachiosaurus

Long tailed and enlarged claws on each hindfoot — Parasaurolophus

Pair of rounded crests on it's skull — Velociraptor

Tyrannosaurus rex measured up to 42ft in length with arms only about 3ft long and could weigh up to 7 tons.

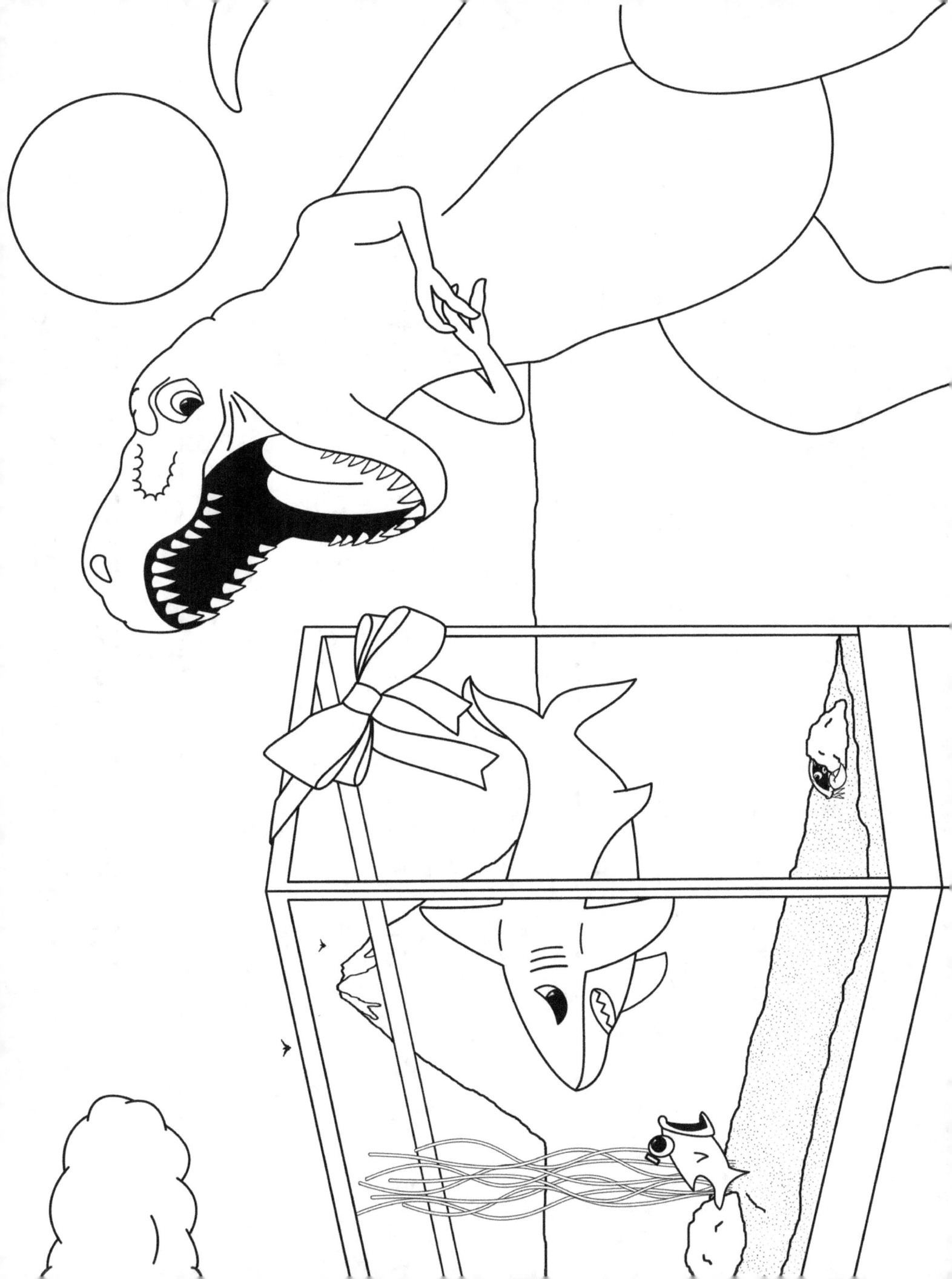

Squiggly Piggly

Follow the lines to see what letter goes in the blank spot.

What's the difference between bird flu and swine flu?

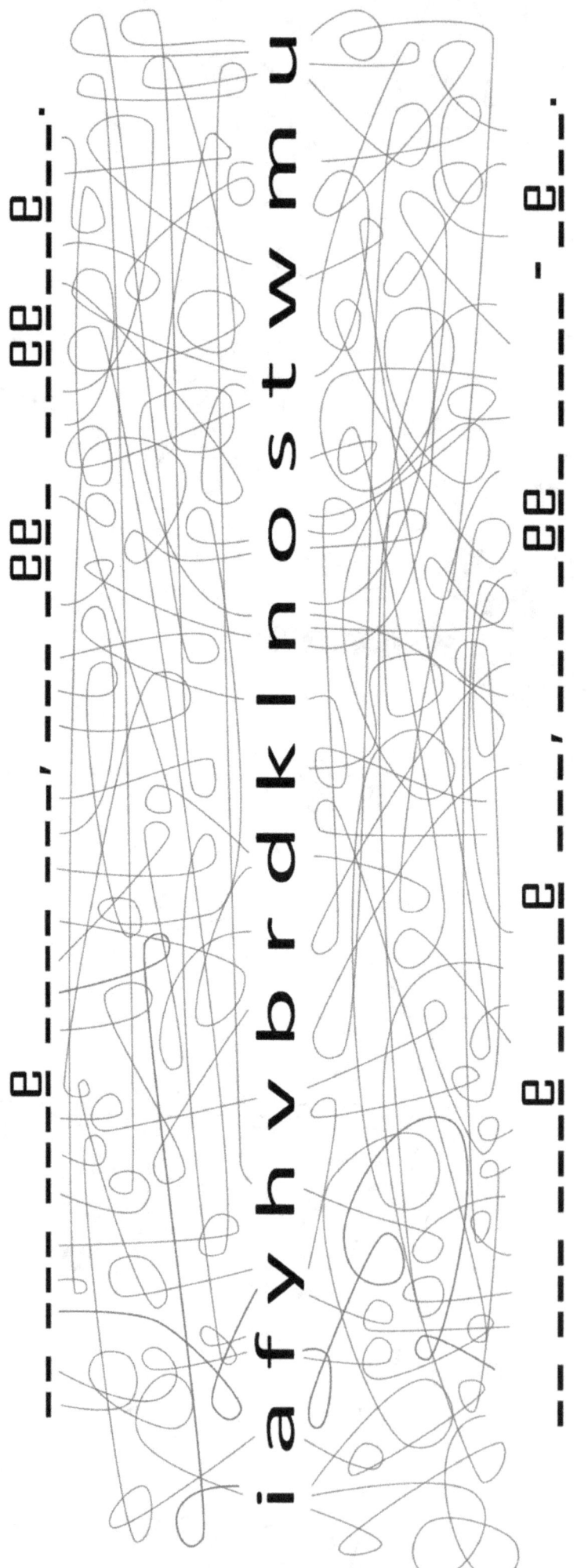

Pigs are omnivores, meaning they eat both plants and meat like humans.

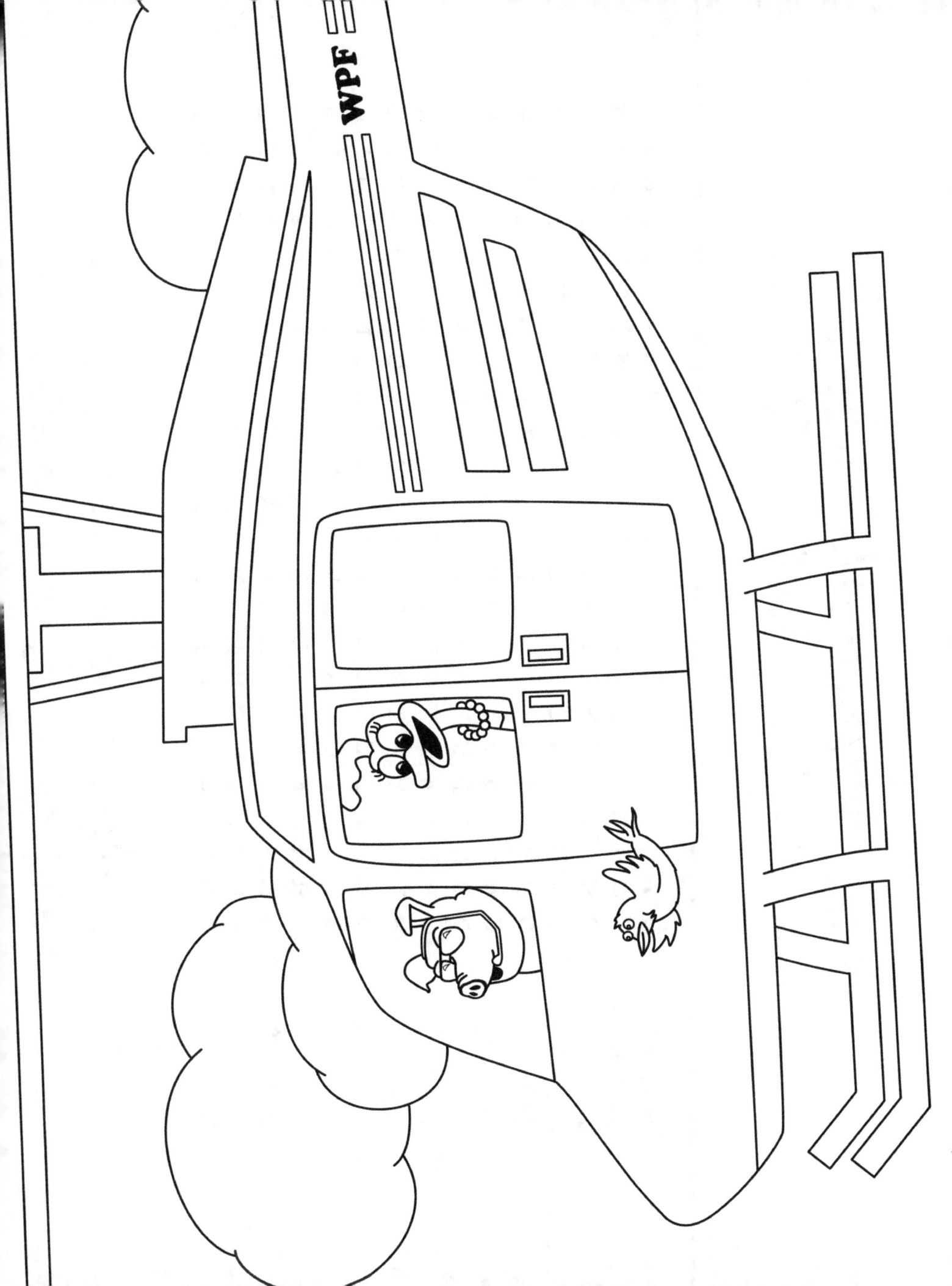

Sea Mammals Search

Only look for the sea mammals. They can be going in any direction. Fowards or backwards.

```
B Y M E A Y W C D T O G J E O A N A I N E R I S
O A N R S W S D N N O T T E J E W R T H C J F M
D V D N N I W T D S B N F V E A N E L E S W
S V C O A W O I J H P V E G E V T A W G M R B D
D P P G S D C P E B D P S U I R N G T S A I V P
O W A L R U S A R D H E G N C J Y N O H P M Y S
D D S J D U N Y I O A T W A J R I N E H N I V D
G P Y F A L F G M L P P E L E D B O I H W A H W
B A O W E B T T L P E H E T E S G N A R S H A E
D L A F P G O O H H N T L J M C M W S E M A E
B F F H E C N R H I T O A S E L V F E J O M O B
S R W M H L V V B N D H N B O S A N W L S S O R
B E M N A R W H A L W D A N J M A I O B A R T S
S D G W S Y C M S G M J M D W V S L B G V B D L
E O B I K O L A F A M T H O M A S L F A E O W T
```

NARWHAL
DOLPHIN
WHALE
CRAB
SHARK
OTTER
SQUID
PENGUIN
MANATEE
OCTOPUS
WALRUS
PORPOISE
SIRENIAN
STINGRAY
SEAL

Female dolphins are called cows, males are called bulls and the young dolphins are called calves.

Nutty Jokes

Q: Why do pandas like old movies?
A: Because they are black and white.

Q: Why don't bears wear shoes?
A: What's the use, they'd still have bear feet!

Q: Where do fish keep their money?
A: In a river bank!

Q: What do you call a mommy cow that just had a calf?
A: Decalfinated!

Q: How is a dog like a telephone?
A: It has a collar I.D.

Q: What do you call a deer that costs a dollar?
A: A buck.

Q: How do you make a goldfish old?
A: Take away the g!

Q: There were 10 cats in a boat and one jumped out. How many were left?
A: None, because they were copycats!

Q: What did the grape say when the elephant stepped on it?
A: It just gave a little wine!

Squirrels teeth never stop growing. Gnawing keeps their teeth from growing too big.

Ant Farm Crossword
Answer the clues to solve the problem.

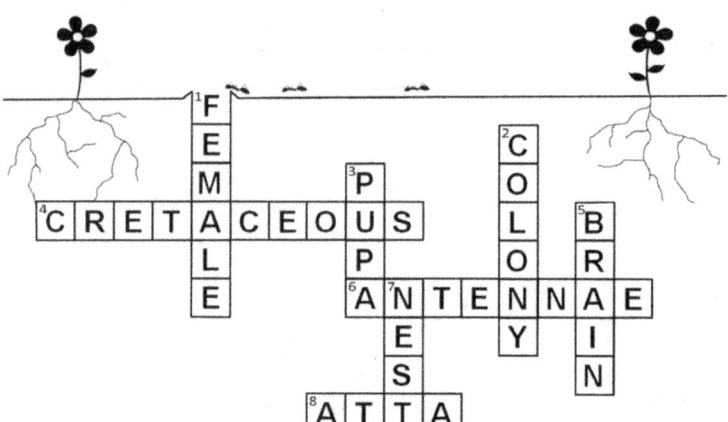

SIGN WITH ME

What did the gorilla call his first wife?

H I S

P R I M E - M A T E !

Sudoku

The Rat Maze

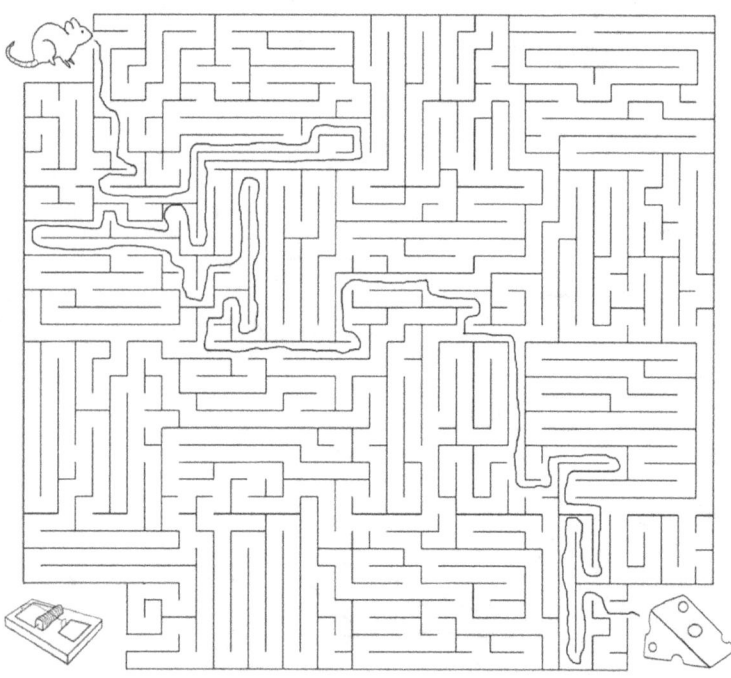

Circus Mayhem

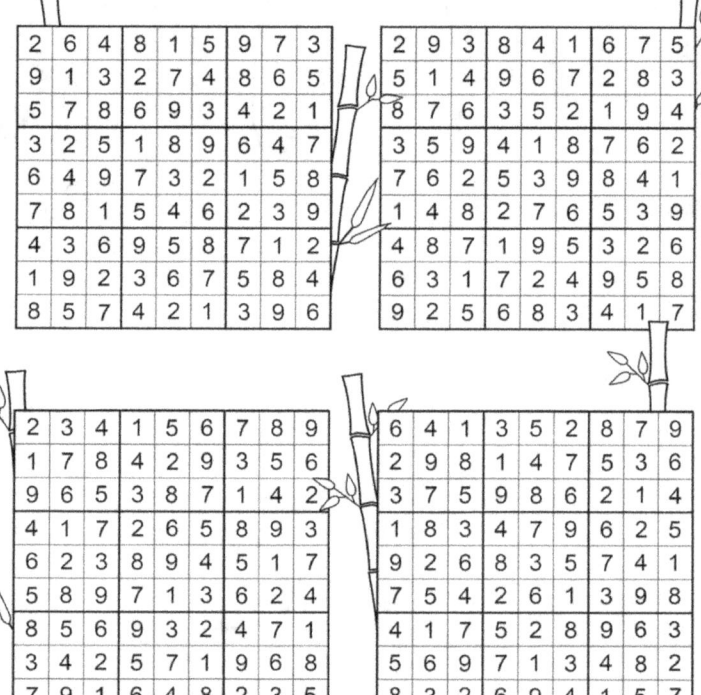

Famous Bunnys
Fill in the blanks to reveal the answer in the box.

What is a bunnys favorite holiday to celebrate?

1. ENERGIZER
2. RABBIT
3. BUGS
4. WHITE
5. THUMPER
6. TRIX

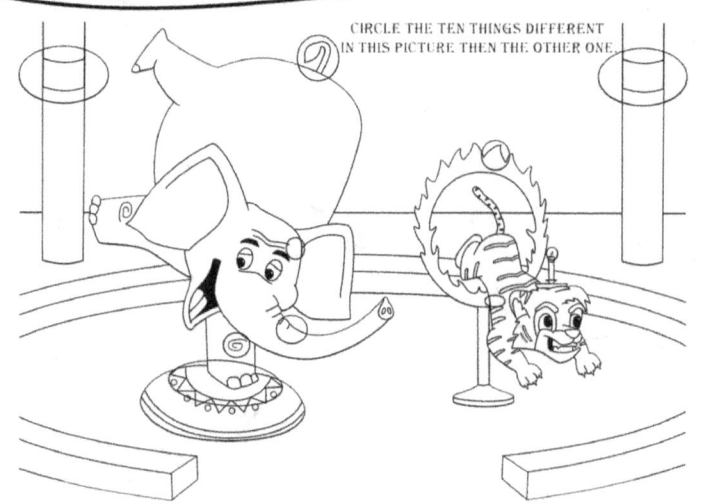

Circle the ten things different in this picture then the other one.

DINO MATCH

- Heavily-armored body and massive bony tail club — Tyrannosaurus
- Large and elaborate cranial crest — Ankylosaurus
- Long neck, small skull, and large overall size — Triceratops
- Massive skull balanced by a long, heavy tail — Dilophosaurus
- Large bony frill and three horns — Pterodactyl
- Has a wingspan up to 40 feet wide — Brachiosaurus
- Long tailed and enlarged claws on each hindfoot — Parasaurolophus
- Pair of rounded crests on it's skull — Velociraptor

Squiggly Piggly

If you have bird flu, you need tweetment.

i a f y h v b r d k l n o s t w m u

If you have swine flu, you need oink-ment.

Sea Mammals Search

```
B Y M E A Y W C D T O G J E O A N A I N E R I S
O A N R S W S D N N O T T E J F W R T H C J F M
D V D N N I W T D S B N F V E A N A N E L E S W
S V C O A W O I J H P V E G E V T A W G M R B D
D P P G S D C P E B D P S U I R N G T S A I V P
O W A L R U S A R D H E G N C J Y N O H P M Y S
D D S J D U N Y I O T W A J R I N E H N I V D
G P Y F A L F G M L P P E L E D B O I H W A H W
B A O W E B T T L P E H E T E S G N A R S H A E
D L A F P G O O O H H N T L J M C M W S E M A E
B F F H E C N R H I T O A S E L V F E J O M O B
S R W M H L V V B N D H N B O S A N W L S S O R
B E M N A R W H A L W D A N J M A I O B A R T S
S D G W S Y C M S G M J M D W V S L B G V B D L
E O B I K O L A F M T H O M A S L F A E O W T
```

NARWHAL, DOLPHIN, WHALE, CRAB, SHARK, OTTER, SQUID, PENGUIN, MANATEE, OCTOPUS, WALRUS, PORPOISE, SIRENIAN, STINGRAY, SEAL

Wild Cats

- AHETEHC — CHEETAH
- AUONMTIN OLIN — MOUNTAIN LION
- GIETR — TIGER
- WSON PDRLEOA — SNOW LEOPARD
- AURJGA — JAGUAR
- RAGOUC — COUGAR
- HTPNARE — PANTHER

LOOK WHAT THE CAT DRAGGED IN.

Animalia TRIVIA

1. The octopus has (1, 2, **3**, 4) hearts.
2. The fastest animal in the world is the (cheetah, **peregrine falcon**, sword fish, turtle).
3. The worlds largest eggs are layed by a (**whale shark**, ostrich, anaconda, elephant).
4. A young male horse is called a (mare, **colt**, filly, stallion).
5. A rhinoceros horn is made of (bone, **keratin**, cartilage, scales).

www.ingramcontent.com/pod-product-compliance
Lightning Source LLC
Chambersburg PA
CBHW081808170526
45167CB00008B/3370